This charming book is a facsimile of a children's alphabet of animals first published in 1899. Commissioned by Glasgow and London publisher Blackie and Son, it contains a short description and a full-page grisaille drawing for each of the animals, with vignettes accompanying the letters of the alphabet. It was the first publication by Scottish artist Carton Moore Park, who specialized in animal subjects, and whose style was strongly influenced by the art of Japan. The quirky drawings, with their modern-looking cropping and close-up perspective, made the book stand out from all other alphabets of the day. When it was first published, critics acclaimed the artist's strong handling and accurate anatomical knowledge, as well as his profound appreciation of the habits and movements of each animal depicted and his close sympathy with his subjects. One reviewer wrote that, 'It is certainly the best book of the kind we have ever seen.' A hundred and twenty years after it appeared, this exquisite rediscovered volume – very much of its moment but modern in spirit – will enchant and inform a new generation of children.

AN ALPHABET
OF ANIMALS

An Alphabet of Animals

of Animals

By

Carton Moore Park

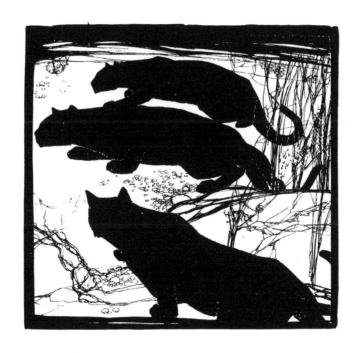

BLACKIE AND SON, LTD.
50 OLD BAILEY LONDON E.C
1899

A

IS FOR THE
ARMADILLO

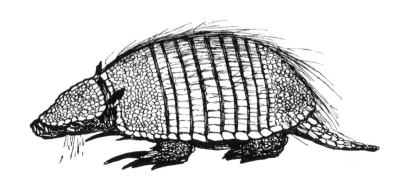

The ARMADILLO is like a knight of the olden days, clad in mail from head to foot. But he is not exactly a fighter, in fact he always prefers to run away. When he is caught, he curls up into a ball like the hedgehog, and lies snug until the enemy is tired of waiting. Then he unrolls himself and digs for his dinner, which consists of many courses, for nothing eatable comes amiss to him. The Armadillo himself is not musical, but the Brazilians among whom he lives turn his shell into a guitar and his tail into a trumpet.

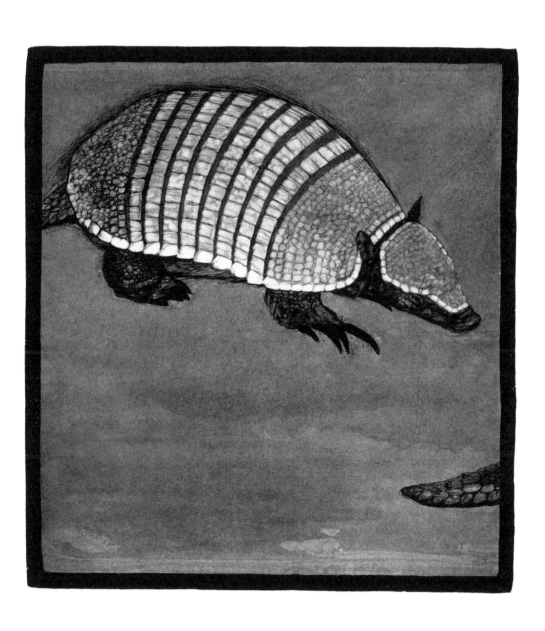

B

FOR BEAR

The SLOTH BEAR shown on the opposite page is never so happy as when he is climbing trees in the forests of India or Ceylon. He is especially fond of fruit, honey, and insects, his favourite dish being a few thousand white ants, which he gobbles up at a single mouthful. Both he and his cousin the Brown Bear may be tamed and taught many amusing tricks. It is usually safest to keep him muzzled, for his temper is rather short; but, as a rule, his hug is worse than his bite.

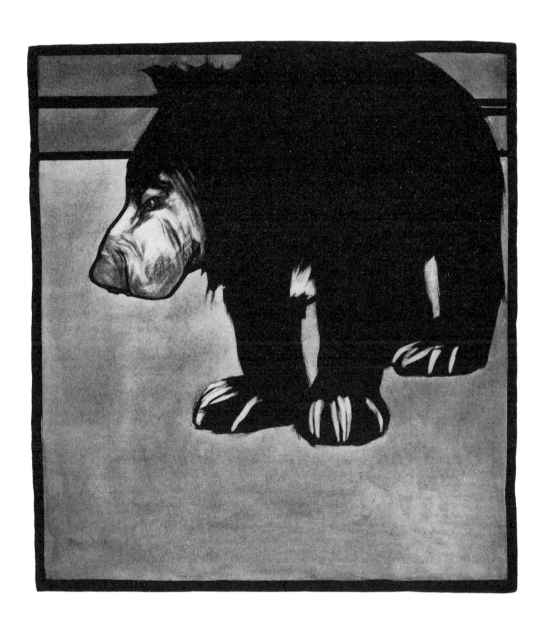

C STANDS FOR **CAT**

The CAT was one of the first animals to be tamed by man. There are still a great many wild cats in this country and in other parts of the world, but our family puss is believed to be descended from the tame cats who lived in Egypt thousands of years ago. She has, too, some very distinguished relations, among whom are the Leopard and the Tiger, whom we shall meet later on. Before she was tamed she used to do most of her hunting after nightfall, for she can see almost as well in the dark as by day. She still remembers this, and that is why she stays up to catch mice after all the rest of the family have gone to bed.

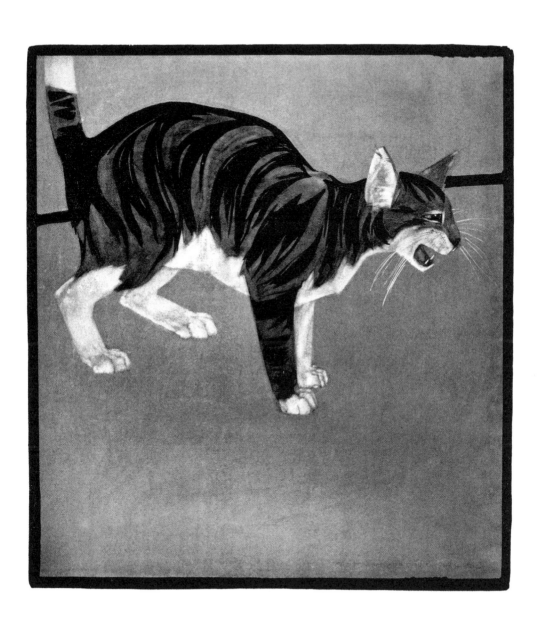

D

for

DROMEDARY

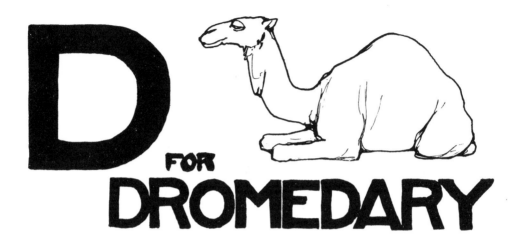

The DROMEDARY is far more useful than beautiful. He has a stout body, long legs, a crooked neck, and a hump; and is very like his cousin the Camel, who has all these and an extra hump. Both live in the deserts of Asia and Africa, where very little water is to be found. So they take a long drink whenever they get the chance, and store away enough water to last them for a week. They are, in fact, a kind of living water tank; and without their aid no traveller would be able to cross the vast wildernesses of sand and rock that are to be found in their native land.

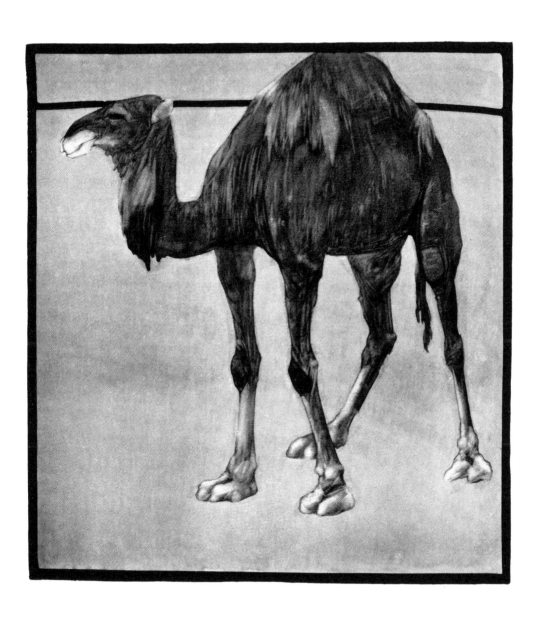

THE
BABY

E

IS FOR

ELEPHANT

The ELEPHANT is the largest and strongest animal on the face of the earth. When tamed and kindly treated he is also one of the gentlest and most affectionate. With his big ears and little eyes, huge tusks and tiny tail, long trunk and short legs, he seems at first sight very clumsy and ungainly, but those who have hunted him in his native forests of India and Africa tell astonishing stories of his speed and skill. The African has longer legs and bigger ears than his Indian cousin, and is less easy to tame. The most valuable possession of the Elephant is his trunk, which serves all kinds of purposes. He uses it as a nose to smell with, as a hand to feel with, as a knife and fork to eat with, and as a bath sponge to wash with.

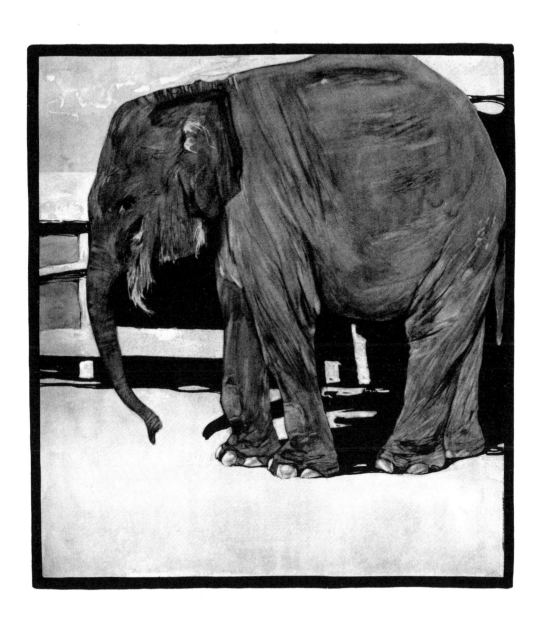

F

IS FOR

FOX

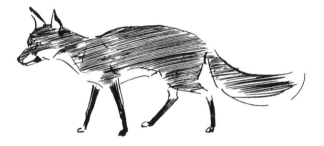

The FOX is sly, very sly. If he were not sly there would soon be no foxes, for Reynard, as he is called, has many enemies and no friends. He is the most cunning thief in the world, and the poultry-yard is never safe while he is in the neighbourhood. Even his den is often stolen from the Badger; but the Fox usually takes care to have a back-door, through which he can slip out when his enemies come in at the front.

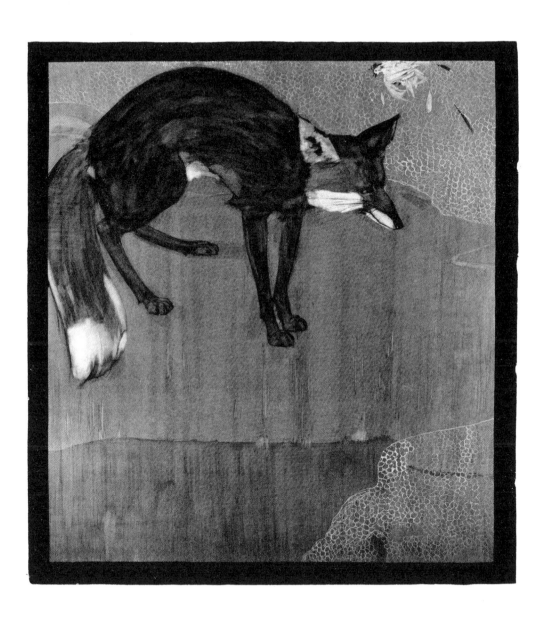

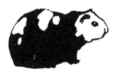

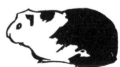

G

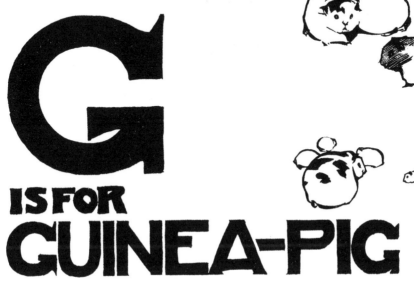

IS FOR

GUINEA-PIG

The GUINEA-PIG is not a pig, and he does not come from Guinea. His native land is South America, but he can make himself at home in any country that is not extremely cold. Ages ago he had, no doubt, a tail, but to-day only a very short stump is left. The Guinea-pig is one of the most helpless of animals, for if he is attacked he is unable to defend himself, and he moves so slowly that he cannot get away.

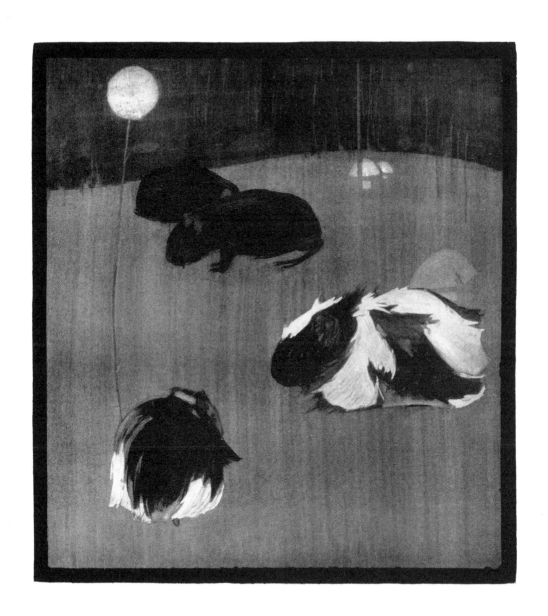

H IS FOR HIPPOPOTAMUS

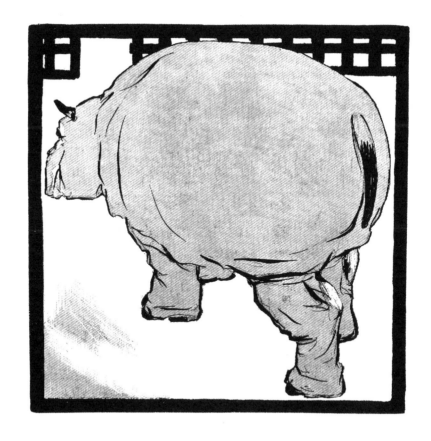

The HIPPOPOTAMUS does not make a pretty picture, but he leads a happy life in the lakes and rivers of Africa. He can paddle in the mud all day, with nobody to tell him that he must keep his feet dry. The greater part of his time is spent in the middle of the river, where he swims about with only his nose showing above the water; but he waddles ashore for his meals, browsing on the coarse grass and weeds that grow on the banks. The baby Hippopotamus is not able to stay under water so long as his parents, so when Mrs. Hippopotamus takes him for a swim she carries him pickaback until he is able to take care of himself.

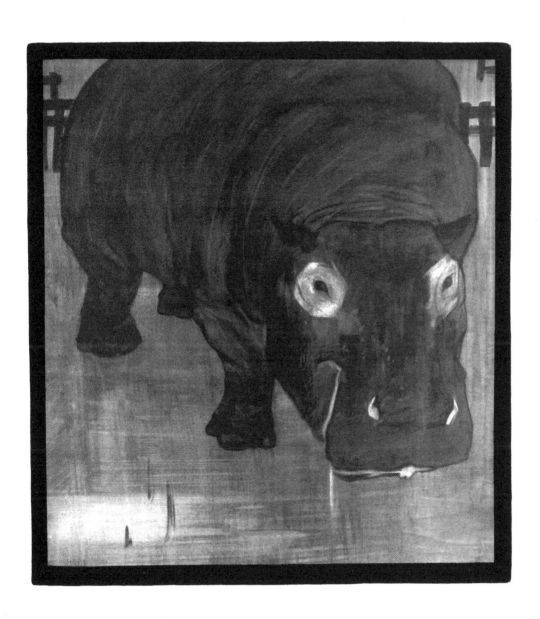

I ISFORTHE IBEX

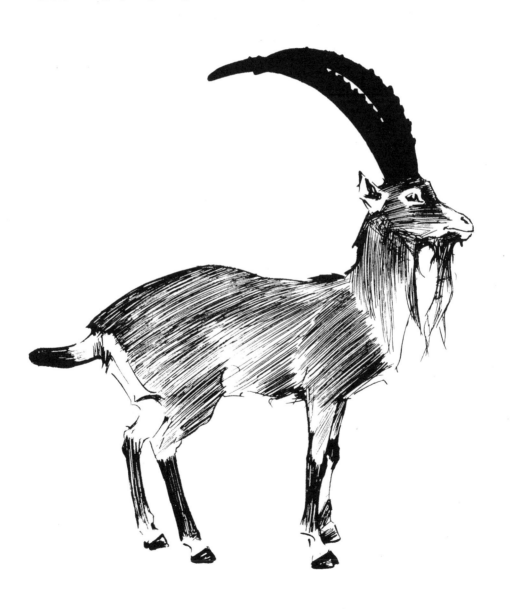

The IBEX is a wild goat that lives high up in the Alps and other great mountains. He is very shy, and in order to avoid being seen changes his coat according to the season. In summer he is a reddish-gray, like the rocks around him, but he is dead gray in winter, when the mountains are covered with snow. The Ibex does not know what it is like to feel giddy. When the hunter is chasing him he can climb the most extraordinary precipices, and as he can generally see his foe long before his foe can see him, he is not at all easy to catch.

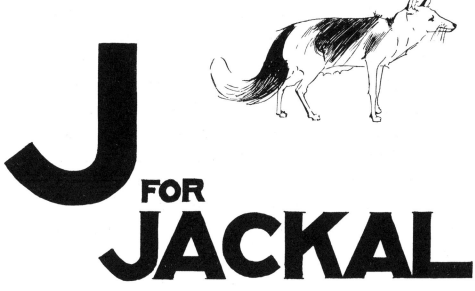

J

FOR

JACKAL

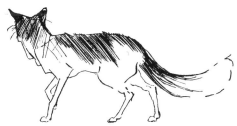

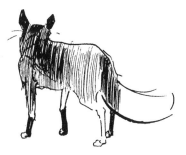

The JACKAL is a small fox-like animal found in India and other parts of Asia. He is more often heard than seen, for the Jackal does not love the light. When dusk is falling he creeps out from his den, and with several companions goes prowling round the villages, howling in the most weird and dismal manner, and picking up scraps of food which most other animals refuse to eat. He will also eat any animal smaller and weaker than himself; but he is a terrible coward, and is so much afraid of being seen, that at dawn he slinks back again to his den and remains hidden throughout the day.

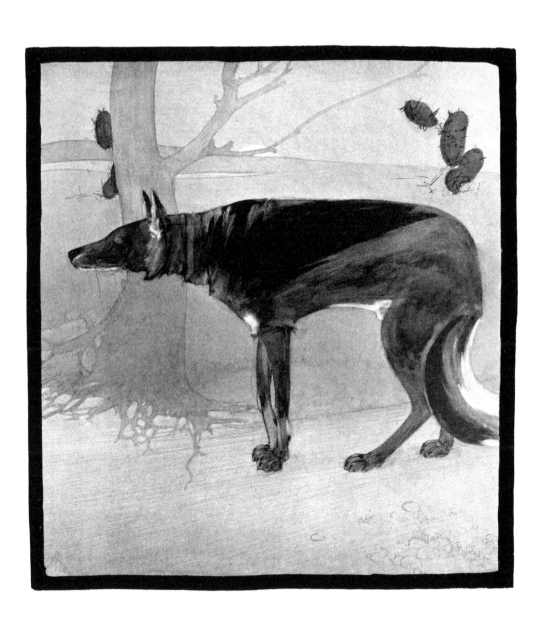

K

FOR THE

KANGAROO

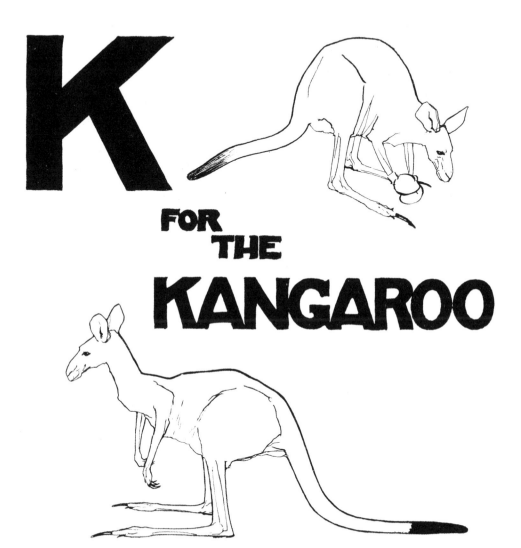

The KANGAROO lives only in Australia, and is very different from most other four-footed creatures. It does not walk or run, but with its immensely long hind legs hops over the ground in huge jumps of fifteen or twenty feet. When it wishes to sit down it makes a kind of camp-stool of its tail and the two hind legs. The mother Kangaroo carries her family shut up in a big pouch, but when they are old enough the little ones are allowed to put their heads out to see what is going on around.

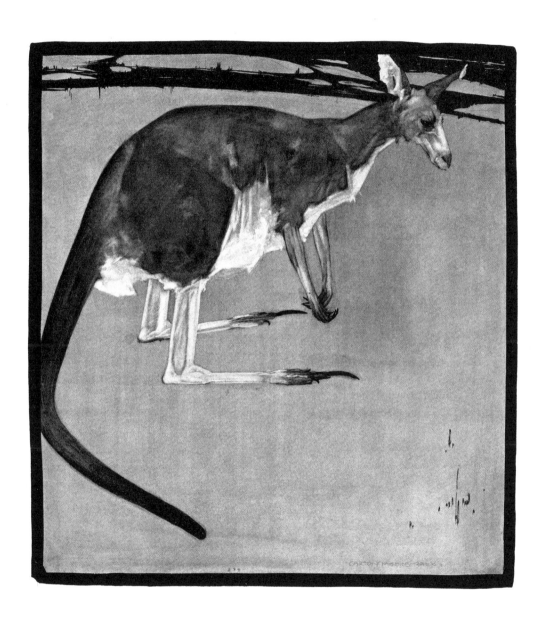

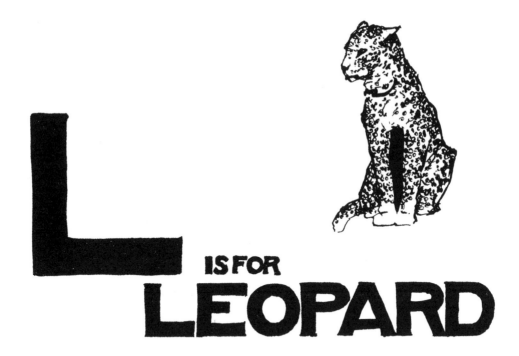

L

IS FOR

LEOPARD

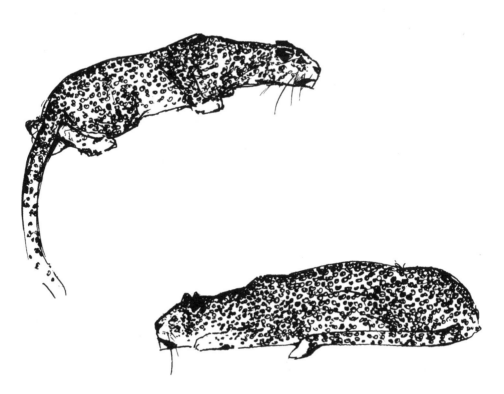

The LEOPARD is like a huge yellow cat marked all over with dark spots. His home is in the forests of Africa and Asia, where he is nearly as much feared as the grim tiger himself. The poor monkeys live in constant dread of this savage foe, for he can climb trees nearly as quickly as they can, and is very cunning in taking them by surprise. He will also climb up on to a branch, and drop down upon any unsuspecting deer or antelope that happens to pass beneath. One would sooner not meet the Leopard, except at the Zoo.

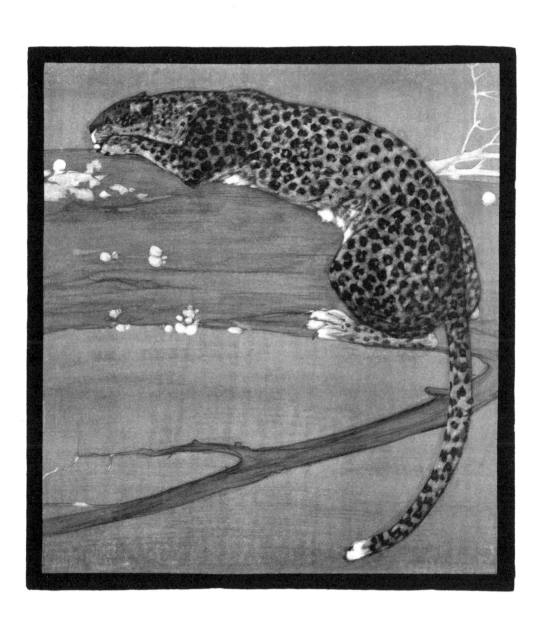

M FOR MICE

Wherever a man may build his house, the little brown MOUSE is sure, sooner or later, to find him out. She does not say "If you please" or "By your leave", but builds her nest in some out-of-the-way corner and begins to gnaw a way into the pantry. Then the man calls in the cat, and one night the little brown Mouse does not return to her nest. But by this time her children are growing up, and there are soon eight or ten other little mice to make nests and rear families and provide suppers for the cat.

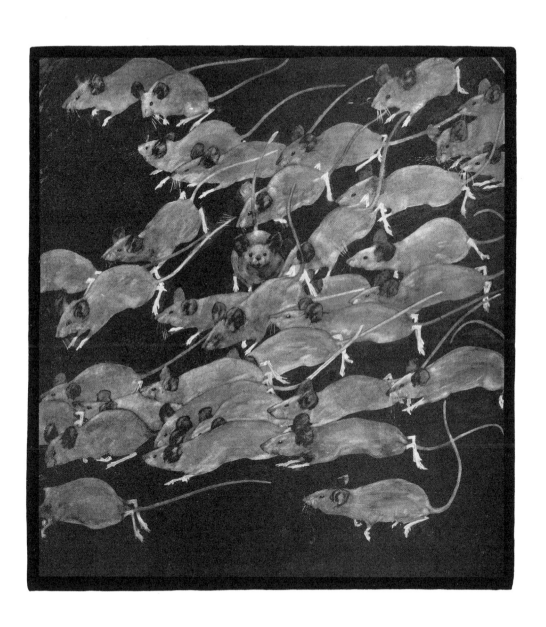

N

FOR

NYLCHAU

Far away in the great forests of India lives the NYLGHAU. He is one of the largest and finest of the antelope family. In colour he is dark gray, with a mane of black hair on the neck, and a tuft of the same colour on the breast. In places where he is not disturbed he becomes extremely tame; but if he is frequently hunted he grows very clever in keeping himself well out of sight.

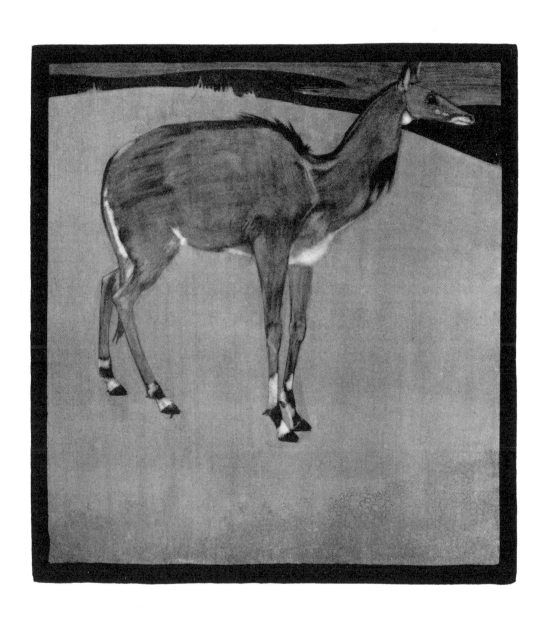

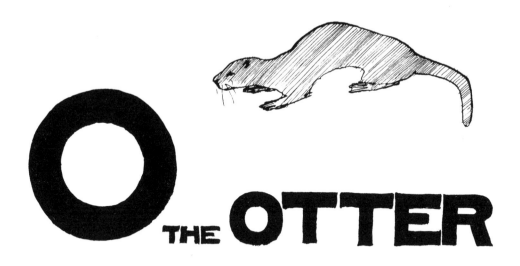

O THE **OTTER**

The OTTER makes his living by catching fish, and no fisherman who stands on the river bank at the end of a rod and a long line is half so clever as he. With his long thin body, short legs, and webbed feet, he can swim and dive with the greatest ease, and a fish must be very quick indeed to escape him. When free the Otter is very wild and fierce, but if caught young he may be tamed and taught to fish for his master.

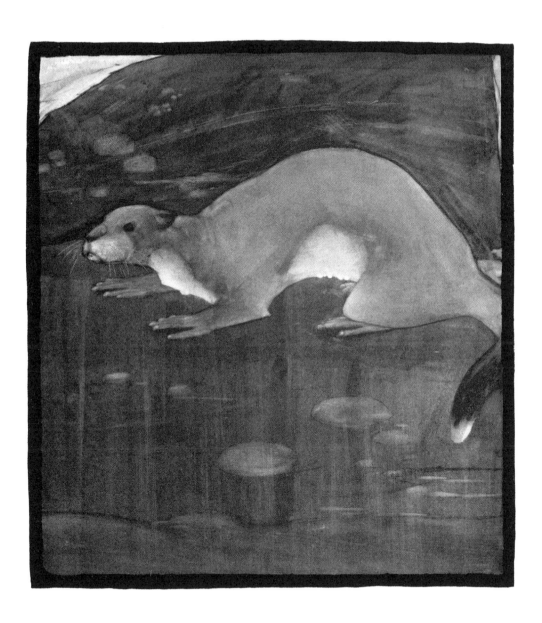

P

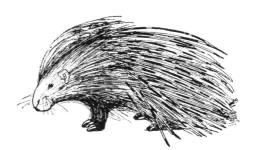

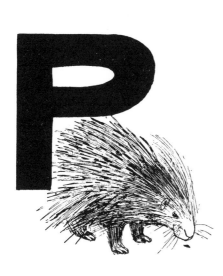

PORCUPINE

The PORCUPINE has a back like a pin-cushion, stuck full of sharp quills. When only his friends are near, these quills lie flat upon his back, but as soon as he sees an enemy he raises them up on end and shakes them about in the most alarming way. Like the Hedgehog and the Armadillo, he can curl himself into a ball, and no foe is able to pierce the forest of spears that protects him at all points. The Porcupine is found in most warm countries, and no doubt has ample use for his quills in scaring away his many powerful enemies in the forests of India and Africa.

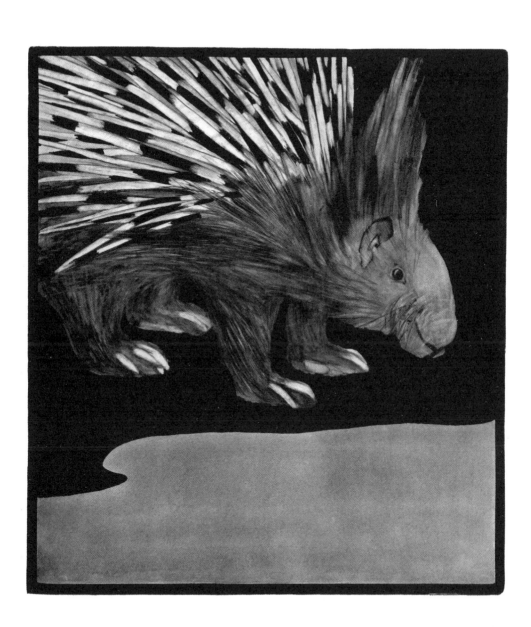

Q IS FOR

QUAGGA

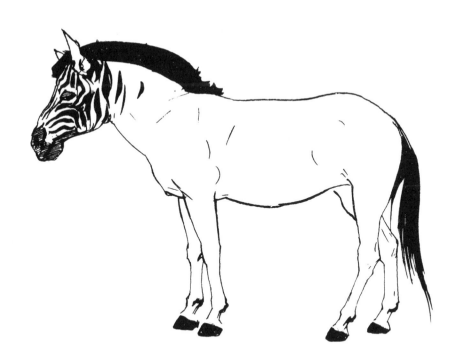

The QUAGGA looks like a Zebra which the painter has forgotten to finish. He has the same stripes on the neck, but few or none on the body and legs. Both the Quagga and Zebra live in the southern parts of Africa, but although they are very nearly related they are not on speaking terms. In his wild state the Quagga is very fierce and not easy to catch, but he can be more easily tamed than the Zebra. His curious name was given to him by the natives of Africa on account of his voice, which is something like the bark of a dog.

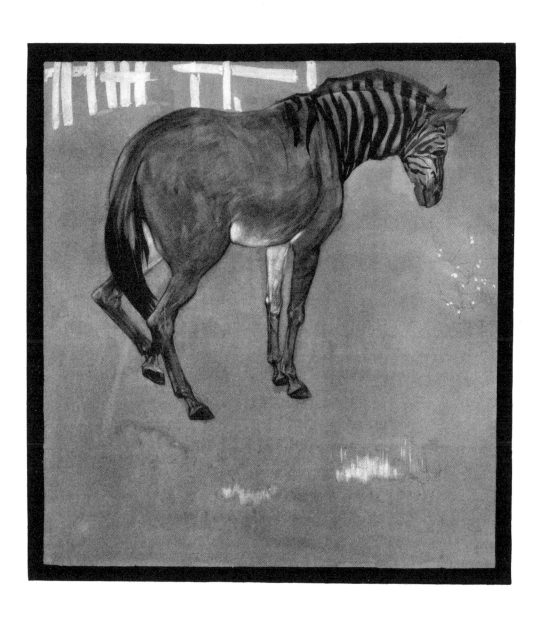

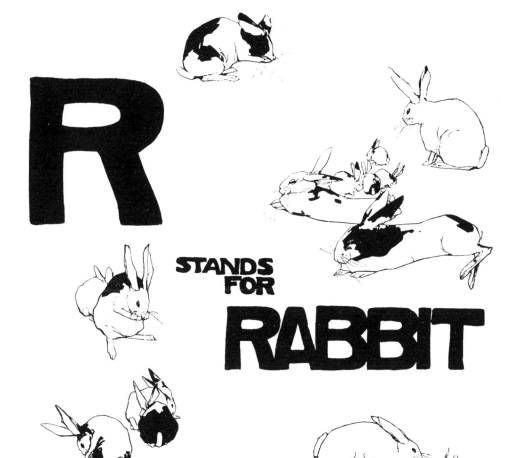

R

STANDS
FOR

RABBIT

The RABBIT belongs to the same family as the Hare, but he has smaller ears and shorter legs. Both are very timid, and when pursued the Rabbit, who cannot run so fast as the Hare, dives underground into his burrow, which is always close at hand. The tame Rabbit has a larger body than his cousin in the woods, and his ears are generally very much longer.

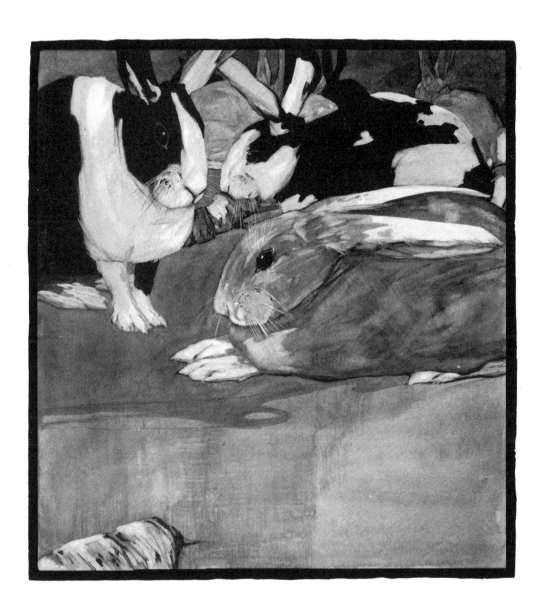

S
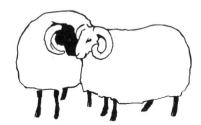

IS FOR

SHEEP

The SHEEP does more for his master than any other animal that has been tamed by man. He can pick up a living in places where most other creatures of his size would starve, and in return for very little attention supplies us with both food and clothing. In this country he is not extraordinary in shape, but he has some strange relations in foreign lands. In the mountains of Asia, for instance, there are Sheep with horns five or six feet in length, while in Arabia there is another kind whose tails are so long and heavy that they have to be carried on little sledges.

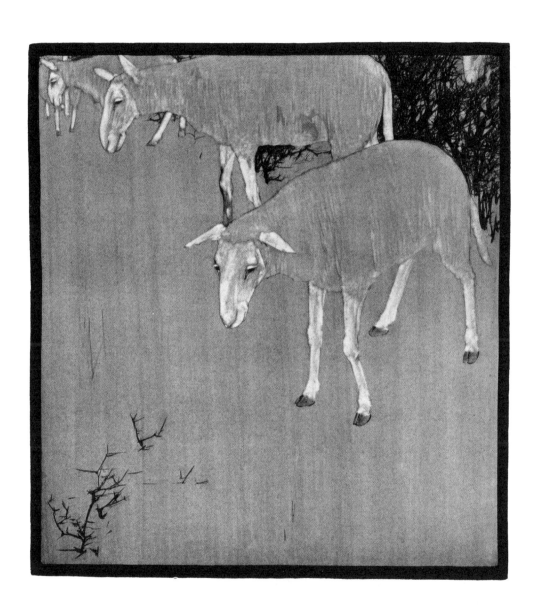

T IS FOR TICER

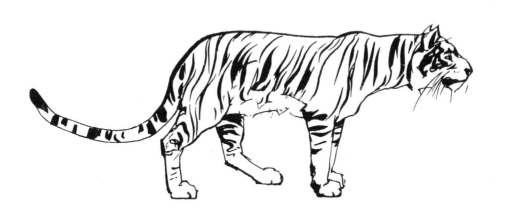

Mr. Stripes, as the Bengal TIGER is often called, is the fiercest and most terrible of four-footed creatures. With a single blow of his huge paw he can kill a buffalo, and can then carry it off in his mouth. Even the boldest of his enemies is afraid to attack him alone, and the hunter who pursues him into his lair in the jungle is usually perched high up on the back of a specially trained elephant. When wounded the Tiger will spring on to the elephant, and attempt to drag the hunter down. Then, if the hunter does not shoot straight he will hunt no more Tigers.

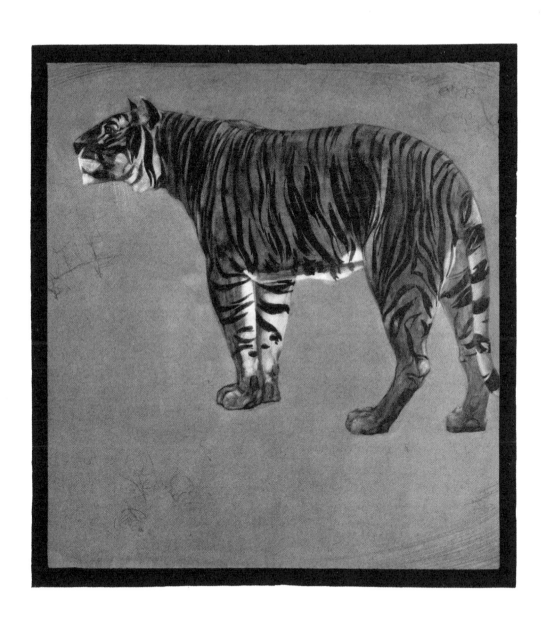

U

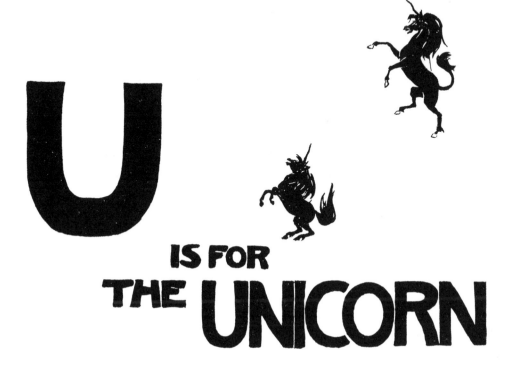

IS FOR
THE UNICORN

There never was a UNICORN. If there were such an animal, he would have the body of a horse, the tail of a lion, and a single horn, like the curl of the little girl in the nursery rhyme, right in the middle of his forehead. In olden times it was supposed that a patchwork animal of this kind lived in India; but of course we are much wiser than our ancestors, and nowadays the Unicorn is put in the make-believe Zoo, together with the Fiery Dragon, the Hippogriff, and other strange animals that never existed.

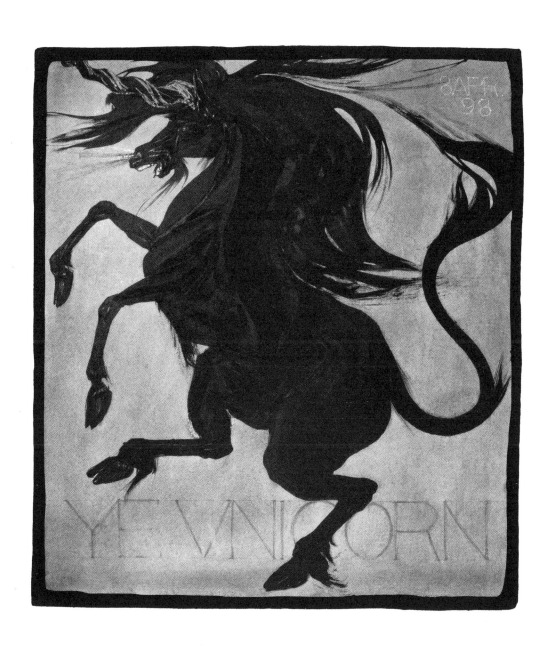

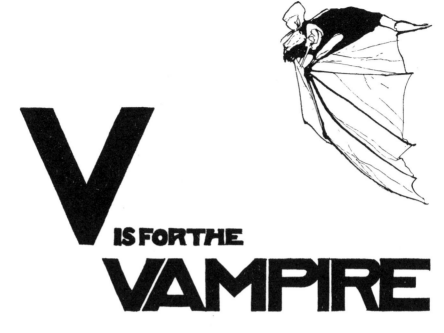

V IS FOR THE VAMPIRE

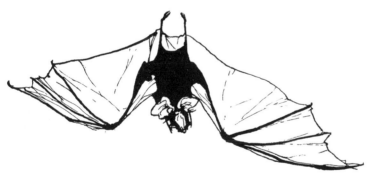

The VAMPIRE belongs to the same family as the bats, who may be seen in this country flitting about at dusk. He is very like a mouse in shape, but at a little distance his two great wings give him the appearance of a bird. Most bats are content to live on fruits and insects, but the Vampire prefers to draw blood from horses or cattle, or even from man himself. His home is far away in South America, and it is to be hoped he will stay there.

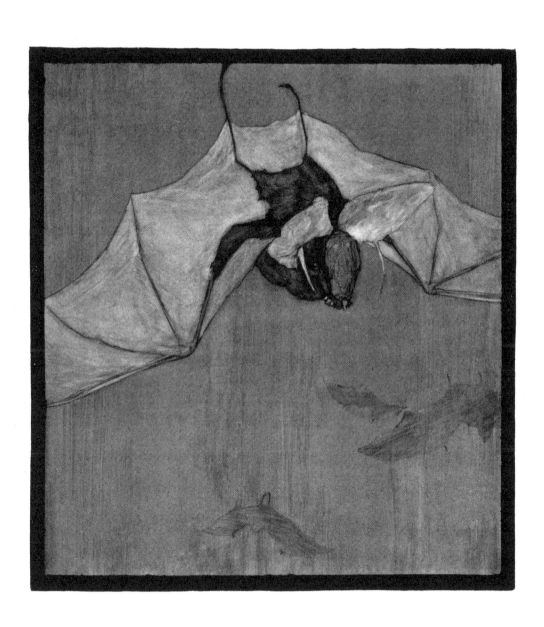

W
FOR
WEASEL

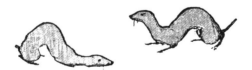

It is very difficult to catch the WEASEL asleep. He is extremely wide-awake, and although only a few inches long is full of courage, and will fight to the last gasp. Woe betide the unlucky hawk or kite that attempts to carry him off. While in mid-air he will gnaw his way into the body of his enemy, and bird and weasel will both come tumbling to the ground. The Weasel is of great use in protecting the farmer against field-mice, but every now and again he requires to be paid for his services, so he helps himself to a duckling or a chicken.

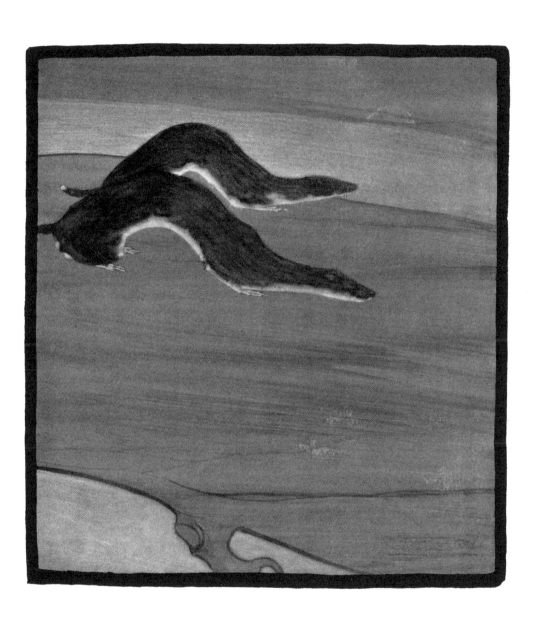

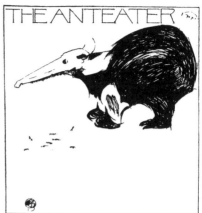

THE ANTEATER

X

IS FOR

TWO EXTRAORDINARY ANIMALS ·

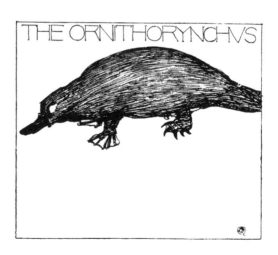

THE ORNITHORYNCHVS

The two EXTRAORDINARY animals are not often seen together as on the opposite page, for the home of the ANT-EATER is in the forests of South America, while the ORNITHORHYNCHUS lives on the banks of Australian rivers. The Ant-eater is a big animal with a slender head, a thick bushy tail, and a very long thin tongue with which it catches the ants that form its food. The Orni-thorhynchus, on the other hand, is a small animal that appears to be partly bird and partly beast. Its body, legs, and tail are like those of an animal, but, strange though it may seem, it lays eggs, and has a bill like a duck.

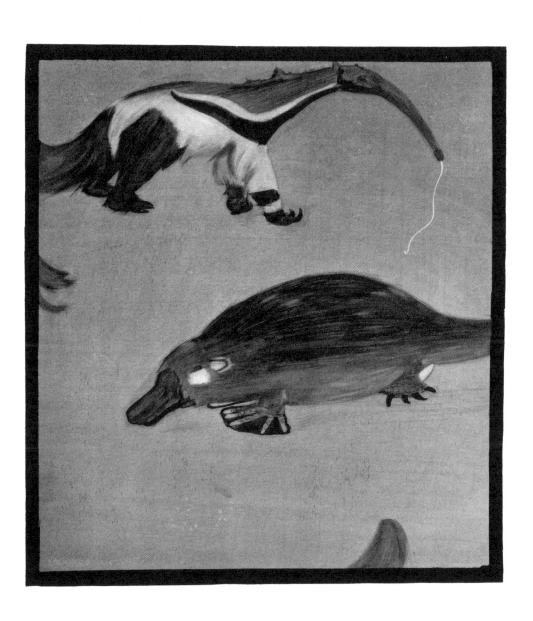

Y IS FOR

YAK

The YAK is a cousin of the Ox, and lives far away in the mountains of Tibet. With his thick shaggy coat he has no fear of cold, but he is unable to bear even moderate heat, and therefore remains high up on the hill-sides throughout the year. His long bushy tail serves him as a capital fly-whisk, and when he is finished with it the Tibetans cut it off and use it for the same purpose.

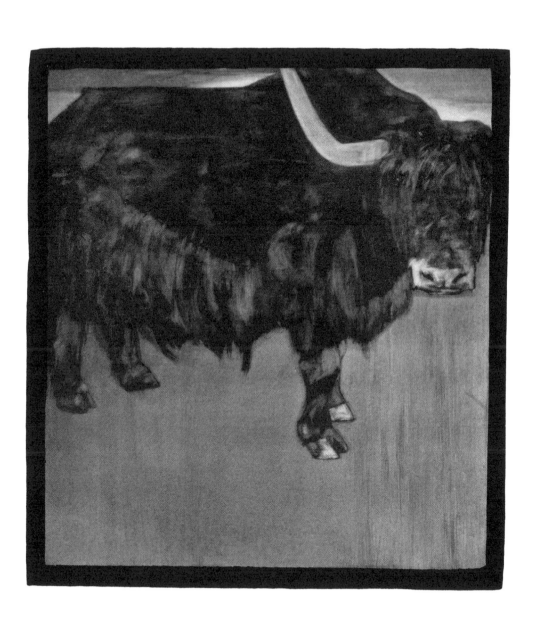

Z IS FOR ZEBRA

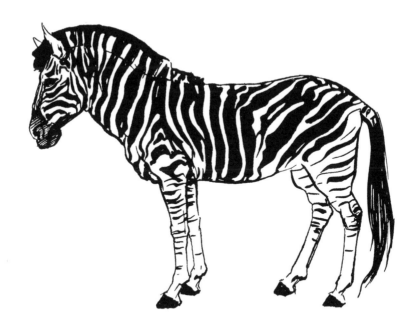

The ZEBRA looks like a white pony painted all over with black stripes. He is extremely shy, and makes his home in the most out-of-the-way parts of South Africa. To every herd of Zebras there is always a sentinel, who gives warning of the approach of danger. When they are unable to run away, the Zebras form a circle with their heads pointing inwards, and kick out at their enemies with their heels.

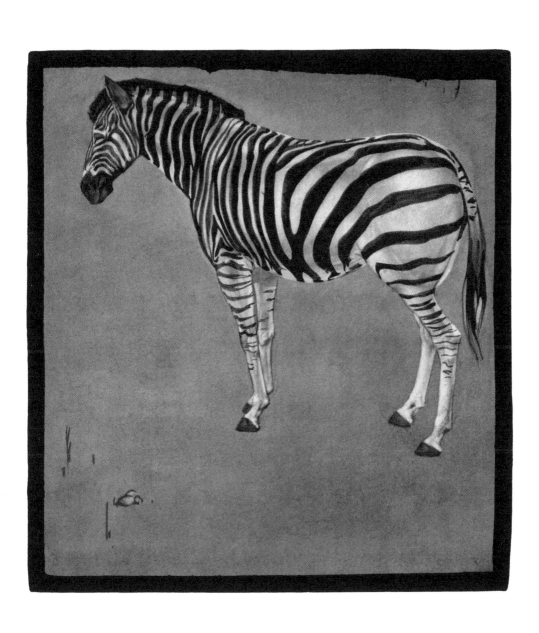

Carton Moore Park (1877–1956) was a British painter,
illustrator, and teacher, born in Scotland. He studied
at the Glasgow School of Art between 1893 and 1897.
During the 1890s, he was best known for his illustrations
of animals, which appeared in the *Glasgow Weekly Citizen* and
Saint Mungo. His illustrated books were *An Alphabet of
Animals*, *Book of Birds*, and *A Book of Elfin Rhymes*. He lived
in London until 1910, when he emigrated to New York,
where he spent the rest of his life.

Also available in the Art / Books facsimile editions

CHILDREN'S CLASSICS

ABC: An Alphabet
Written and pictured by Mrs Arthur Gaskin
First published in London and Chicago in 1895
ISBN 978-1-908970-36-7

Little Women
by Louisa M. Alcott
Abridged by W. Dingwall Fordyce
Illustrations by Norman Little
First published in London in 1910
ISBN 978-1-908970-40-4

A Book of Elfin Rhymes
by 'Norman'
With drawings by Carton Moore Park
First published in London in 1900
ISBN 978-1-908970-39-8

VINTAGE CLASSICS

The Art of Rodin
Introduction by Louis Weinberg
First published in New York in 1918
ISBN 978-1-908970-38-1

The Art of Aubrey Beardsley
Preface and introduction by Arthur Symons
First published in New York in 1918
ISBN 978-1-908970-37-4

Paul Gauguin's Intimate Journals
Translated by Van Wyck Brooks
Preface by Émile Gauguin
First published in New York in 1921
ISBN 978-1-908970-45-9

For more information and to purchase copies,
please visit www.artbookspublishing.co.uk

First published in the United Kingdom in 1899 by Blackie and Son Ltd

This facsimile edition first published
in the United Kingdom in 2019 by Art Books Publishing Ltd

Art Books Publishing Ltd
18 Shacklewell Lane
London E8 2EZ
Tel: +44 (0)20 8533 5835
info@artbookspublishing.co.uk
www.artbookspublishing.co.uk

British Library Cataloguing-in-Publication Data
A catalogue record for this book is available from the British Library

ISBN 978-1-908970-46-6

Designed by Art / Books
Printed and bound in Latvia by Livonia

Distributed outside North America by
Thames & Hudson
181a High Holborn
London WC1V 7QX
United Kingdom
Tel: +44 (0)20 7845 5000
Fax: +44 (0)20 7845 5055
sales@thameshudson.co.uk

Available in North America through
ARTBOOK | D.A.P.
75 Broad Street, Suite 630
New York, N.Y. 10004
www.artbook.com